GAY ROBIN

EGYPTIAN PAINTING AND RELIEF

BIRKBECK COLLEGE
UNIVERSITY OF LONDON

This book

should be returned to the

Extra-Mural Library

SHIRE EGYPTOLOGY

Cover photograph
The king and Hathor in the tomb of Tuthmosis IV
in the Valley of the Kings.
(Photograph taken by kind permission of
the Egyptian Antiquities Organisation.)

British Library Cataloguing in Publication Data available.

Published by
SHIRE PUBLICATIONS LTD
Cromwell House, Church Street, Princes Risborough,
Aylesbury, Bucks HP17 9AJ, UK

Series Editor: Barbara Adams

Copyright © Gay Robins, 1986.
All rights reserved.
No part of this publication may be reproduced or transmitted
in any form or by any means, electronic or mechanical,
including photocopy, recording, or any information storage
and retrieval system, without permission in writing
from the publishers

ISBN 0 85263 789 6

First published 1986; reprinted 1990.

Set in 11 point Times and printed in Great Britain by
C. I. Thomas & Son (Haverfordwest) Ltd,
Press Buildings, Merlins Bridge, Haverfordwest, Dyfed.

Contents

4

List of illustrations

Chronology

From Murnane, W. J. *The Penguin Guide to Ancient Egypt*, 1983.

Early Dynastic Period	3050 - 2613 BC	Dynasties I to III
Old Kingdom	2613 - 2181 BC	Dynasties IV to VI
First Intermediate Period	2181 - 2040 BC	Dynasties VII to XI (1)
Middle Kingdom	2040 - 1782 BC	Dynasties XI (2) to XII
Second Intermediate Period	1782 - 1570 BC	Dynasties XIII to XVII
New Kingdom	1570 - 1070 BC	

1570 - 1293	*Dynasty XVIII*
1386 - 1349	*Amenophis III*
1350 - 1334	*Amenophis IV/Akhenaten*
1336 - 1334	*Smenkhkare*
1334 - 1325	*Tutankhamun*
1325 - 1321	*Ay*
1321 - 1293	*Horemheb*
1293 - 1185	Dynasty XIX
1293 - 1291	*Ramesses I*
1291 - 1278	*Seti I*
1279 - 1212	*Ramesses II*
1185 - 1070	Dynasty XX
1182 - 1151	*Ramesses III*

Third Intermediate Period	1070 - 713 BC	Dynasties XXI to XXIV
Late Period	713 - 332 BC	Dynasties XXV to XXXI
Graeco-Roman Period	332 BC to AD 395	Ptolemies and Roman Emperors

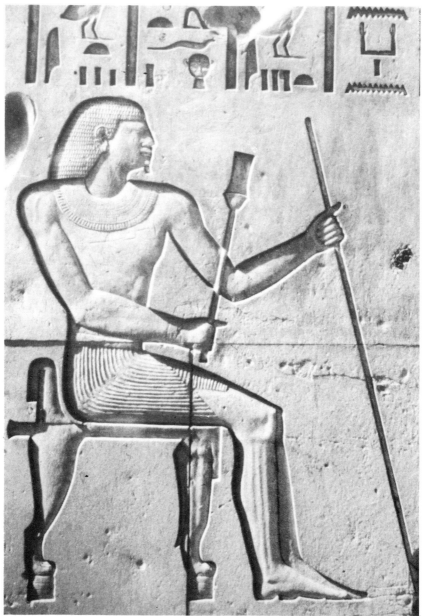

1. Seated figure of Sarenput I in his tomb at Aswan, Twelfth Dynasty. (Author's photograph.)

1
Introduction

Much of what we know about the civilisation of ancient Egypt comes to us through its art, particularly the decoration of temples and tombs, which, because of the favourable climate, has been preserved in large quantities. If we are to interpret this vast store of evidence correctly, it is necessary to consider the character and purpose of Egyptian art.

The appreciation of art is possible on two levels: it can be based on judgements made according to the intentions of the original artists, or on the immediate impact which a piece of art makes on the viewer, although he may know nothing of its underlying purpose. Today Egyptian art appeals to many people on the second level, but an even greater appreciation of it can be achieved if we also try to understand it on the first, for then what may appear to be shortcomings are often found to be a true expression of the artists' principles and aims.

The Egyptians did not compose 'art for art's sake'. What are now regarded as their works of art were produced to fulfil specific functions, either in religious or everyday contexts. Thus the decoration of tombs and temples had a ritual purpose, whose aim was to depict the major figures of the tomb owner, the king and deities in the timeless, idealised worlds of the dead and the gods. Although the depiction was conceived in terms of this world, by making the scenes independent of time and space the artist was able to symbolise an eternal, abstract world; this gave a very formal and static character to religious art (figs. 1, 2). By contrast, in subsidiary tomb scenes that did not involve the major figure of the tomb owner and in domestic art the artist often depicted scenes and activities that were part of the transient world around him with all the vitality and immediacy of everyday life (fig. 3).

Few artistic compositions can be assigned to a particular artist, and although some individual names have come down to us it is clear that the production of artistic work was usually undertaken by a team of men working together. We have to ask, therefore, whether we should speak of artists in ancient Egypt or of craftsmen. However, each team seems to have been led by a master draughtsman who probably conceived the original design and then oversaw each stage of production, correcting the work of his men where necessary and perhaps adding the final touches.

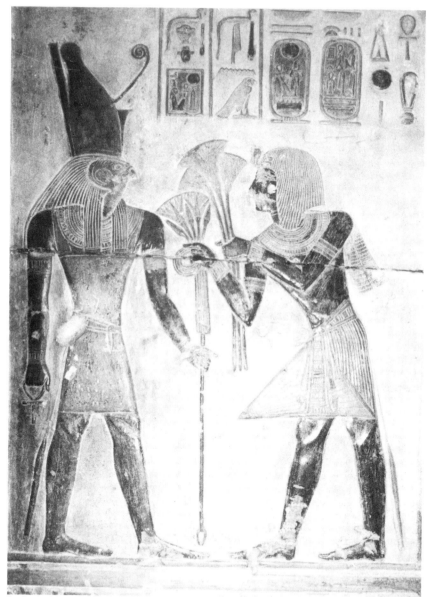

2. Scene showing the king offering flowers to Horus in the temple of Seti I at Abydos, Nineteenth Dynasty. (Author's photograph.)

Such people can surely be spoken of as 'artists', and one cannot regard the greatest works of Egyptian art as other than the creation of an individual artistic mind.

Artists were almost certainly trained by serving an apprenticeship under a master. They would learn how to render different objects, including parts of the human figure and common poses, by making trial copies on flakes of limestone or fragments of pottery, materials that were readily available without cost. A number of these pieces survive, some with the master's corrections. The elements which went to make up a scene would have been learnt by practice rather than conceived spontaneously during composition, but the innumerable variations between scenes of similar type (and no two are exactly alike) suggest that each entire scene was composed as an individual entity.

Since a complete survey of Egyptian painting and relief in all aspects would take up many lengthy volumes, this book will be limited to explaining the principles of representation according to which the artist worked, describing the materials and techniques used, and examining the characteristics of formal scenes and figures in temples and tombs, the contrasting subsidiary scenes in tombs and the informal art found in domestic contexts.

3. Detail of fragment showing musicians and dancers from the tomb of Nebamun, Eighteenth Dynasty. (British Museum EA 37984; reproduced by courtesy of the Trustees of the British Museum.)

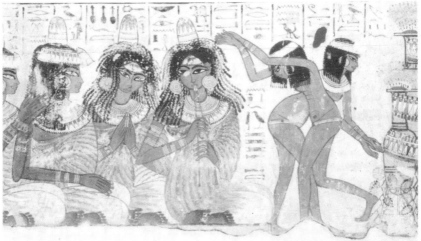

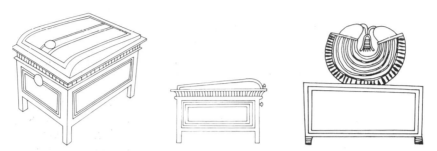

4. (Above) *(From left)* **(a)** Wooden box for storing scribal equipment, Eighteenth Dynasty. **(b)** Representation of a box in the tomb of Ramose at Thebes, Eighteenth Dynasty. (After Davies.) **(c)** Representation of a box containing a necklace in the tomb of Rekhmire, Eighteenth Dynasty. (After Davies.)

5. (Below) *(Top left to bottom right)* **(a)** Representation of a chair in the tomb of Ramose at Thebes, Eighteenth Dynasty. (After Davies.) **(b)** Representation of a stool in the tomb of Hesire at Saqqara, Third Dynasty. (After Quibell.) **(c)** Representation of a chair in the tomb of Hesire at Saqqara, Third Dynasty. (After Quibell.) **(d)** Representation of a pair of sandals in the tomb of Menkheperresonb at Thebes, Eighteenth Dynasty. (After Wilkinson and Hill.)

2
Principles of representation

Egyptian two-dimensional representational art acquired a distinctive character around the beginning of the Dynastic Period and, despite the various changes and developments that occurred, it remains to our eyes unmistakably Egyptian throughout Pharaonic times. Superficially, much of the art appears familiar to western eyes, so that we can often look at a scene and comprehend it intuitively. This leads people to ask why the Egyptians failed to take what seems like the obvious next step and discover perspective. But such a question is misplaced and arises from a lack of understanding of Egyptian art, since its basic principles differ completely from western artistic conventions. Essentially, a set of accepted symbols was used to encode information for the viewer to read, so that drawings of figures and objects can be regarded as diagrams of what they represent. If these were to be immediately comprehensible and unambiguous, they had to communicate an objective truth, independent of time and space. The artist, therefore, showed things in what were regarded as their real forms, and there was no place for what would have been seen as the distortion of perspective. Thus, the use of foreshortening and the adoption of a single uniform viewpoint for an entire picture, which are the basis of western perspective, were irrelevant to the artist's purpose. In this sense, Egyptian art was conceptual rather than purely perceptual. The tantalising feeling of realism results from the use of a mosaic of percepts, put together in a semi-realistic manner.

Objects were usually shown in their characteristic or most visually satisfying aspect, two-dimensionally on the flat drawing surface, without depth. For instance, rectangular objects, like a box (fig. 4a), would be represented in full view from the front or side (fig. 4b), depending on which gave the more instantly recognisable shape for the type of object concerned. If the contents of a container were important, they were drawn above it, although they were inside (fig. 4c). Furniture was also normally represented in profile, so that chairs (fig. 5a) and stools appear with only two legs and no depth; occasionally the seat was also shown as a rectangle above the profile but in the same plane (fig. 5b), or the back of a chair was placed in full view above the seat and legs in profile (fig. 5c). On the other hand, objects with breadth but little depth, like scribal palettes, sandals (fig. 5d) and

animal skins, were generally shown from above.

The schematic nature of Egyptian representation is clearly shown in drawings of gardens laid out round a pool (fig. 6). The water appears as a rectangle, on the surface of which may be drawn plants, birds, fish or boats; in real terms, some of these are actually in the water, while others only float on it. Rows of trees planted around the four sides of the pool apparently lie flat on the ground, as may the entrance gateway to the garden. The whole is, however, an efficient plan of a garden which is readily understood and convertible into real terms.

The human figure was represented by a composite diagram constructed from what was regarded as the typical aspect of each part of the body; yet the whole is immediately recognisable (fig. 7). The head was shown in profile, into which were set at the appropriate place a full-view eye and eyebrow and a half mouth. The shoulders were shown full width from the front, but the boundary line on the forward side of the body from armpit to waist, including the nipple or, on a woman, the breast, was in profile, as were the waist, elbows, legs and feet. It was traditional to show both feet from the inside with a single toe and an arch. This emphasises the underlying composite form of the figure,

6. Representation of a pool surrounded by trees in the tomb of Rekhmire at Thebes, Eighteenth Dynasty. (After Davies.)

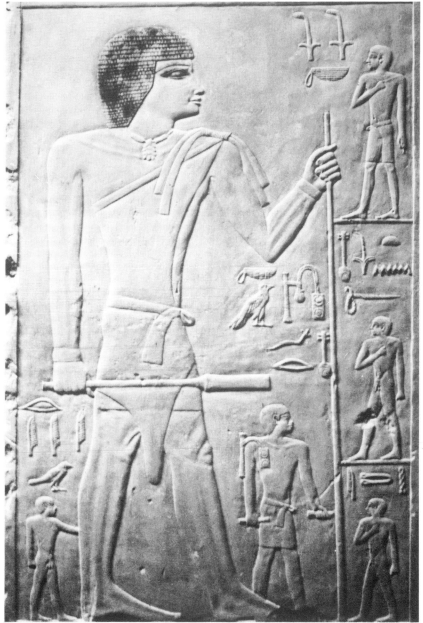

7. Standing figure of Iry from his tomb at Giza, Fifth Dynasty. (British Museum EA 1168; author's photograph.)

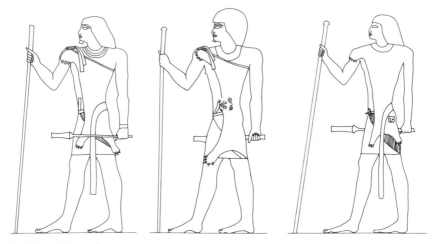

8. *(From left)* **(a)** Standing figure of a man facing left in the tomb of Nefer and Kahay at Saqqara, Fifth Dynasty. **(b)** Standing figure of a man facing left in the tomb of Niankhkhnum and Khnumhotpe at Saqqara, Fifth Dynasty. **(c)** Standing figure of a man facing left in the tomb of Nefer and Kahay at Saqqara, Fifth Dynasty. (All after Ahmed Moussa and Altenmüller.)

according to which it made perfect sense to have one form symbolising 'foot' which was then used without differentiation for both near and far feet. For the arch of the foot to be shown, the bottom of the whole foot had to be raised from the ground; by a logical extension, whatever lay behind the foot might be seen through the gap of the arch, although this could not correspond with reality, since in life the outer side of the foot is not arched (fig. 1). True rendering of the near foot from the outside showing all five toes was experimented with in a few cases during the reigns of Tuthmosis IV and Amenophis III. It was taken up as a distinguishing mark of members of the royal family in the Amarna period (chapter 6). Afterwards, it continued to appear sporadically during the New Kingdom, and it became the more usual mode of representation in the Ptolemaic Period.

Hands were usually represented in full view, either open or clenched, the former from the back showing the nails (cover), and the latter from the front showing the nails or from the back showing the knuckles (fig. 8). At first glance, artists often seem to have had problems with the hands, confusing right and left. In part, the explanation is the same as for the feet: what is shown is the symbol for hand, not the hand as it would appear on a body in

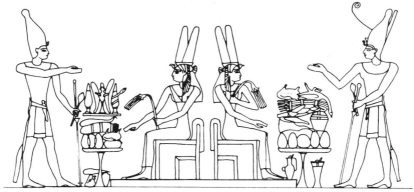

9. 'Double' scene on the stele of king Ahmose dedicated to queen Tetisheri at Abydos, Eighteenth Dynasty. (Cairo Museum CG 34002; after Lacau.)

real life. This is most readily seen in standing figures where both arms hang vertically downwards with the hands open; these are shown identical in form, so that on the rear arm the thumb is on the side furthest from the body and not the nearest as in life (cover). This did not happen with the clenched hand, presumably because it could be shown from either the back or the front, and the rear fist hanging by the side of the body has its thumb next to the body (fig. 7).

Further problems with the hands arose from the fact that certain objects were, in life, carried in a particular hand. From statues, we know that the long staff carried by Old Kingdom tomb owners was held in the left hand, while the short sceptre was carried by the side of the body in the right. In two-dimensional figures looking towards the viewer's right, there was no problem in placing the long staff correctly in the left hand, which was the forward one, and the sceptre in the right hand, which was the rear one (fig. 7). When such figures were reversed to face left, logically the left arm carrying the staff should become the rear arm and the right arm with the sceptre the forward one. With such an arrangement, the sceptre would stick out in advance of the body, while the staff held in the rear arm would not only run unattractively close to the body and threaten to obscure the face but would also cross the horizontal line of the sceptre, making an ugly and confusing image. The artist, therefore, continued to place the staff in the forward arm and the sceptre in the rear one even in left-facing figures. Sometimes, such figures were complete reversals of right-facing ones (fig. 8a); if they are

interpreted in real terms, the staff and sceptre appear in the wrong hands. In other cases the artist wanted to keep the objects in the correct hands, so that he attached a left hand to the forward arm and a right hand to the rear one (fig. 8b). A related issue was whether the sceptre should pass in front of or behind the body of a left-facing figure. If a man facing left holds his sceptre by the side of his body in the right hand, then his body will come between the sceptre and the viewer, and the artist might reproduce this effect on left-facing figures, irrespective of whether he had placed the sceptre in a left or right hand (figs. 8b and c).

In figures where objects could be retained in the correct hand without producing an awkward outline there was no problem. So in some offering scenes the king stretches his right hand over the offerings while he holds a staff and mace in his left hand. When the figure faces right, his rear (or right) arm crosses his body with the hand extended towards the offerings while the forward (or left) arm holds the staff and mace in front of him (fig.9 left). When the figure faces left, the forward (or right) arm is extended in front of the body towards the offerings and the rear (or left) arm crosses the body and holds the staff and mace in front (fig. 9 right). The king's staff was shorter than that held by the tomb owner, so there was no danger in the left-facing figure that it would overlap the face.

Statue groups show that it was most usual for a man and his wife or mother to stand or sit side by side, with the woman on the left. In two dimensions such groups were portrayed by placing one figure in advance of the other. The man is always to the front because this was the more prestigious position and he was the more important partner. The woman often embraces the man by putting her arm round his shoulders and, in reality, since she is on his left, she uses her right arm. The primary orientation in hieroglyphs and in art is towards the viewer's right, left-facing figures and groups tending to be a reversal of compositions originally worked to face right. However, when a man and his wife are drawn facing right the woman's right arm is the rear one, but if the man is to retain his position in front she must still embrace him with her forward arm. This gives the visual impression that she is on his right, which is not usually the case in real terms. Nevertheless, the man's position on the right in right-facing groups can be indicated by placing the heel of his foot over the toes of the woman in standing figures or his buttocks over the woman's knees in seated figures (fig. 56a). When such a

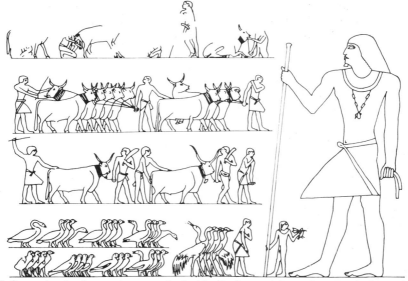

10. Scene showing four registers overlooked by the figure of the tomb owner, in the tomb of Ptahhotpe at Saqqara, Fifth Dynasty. (After Davies.)

group is reversed to face left, the woman's forward arm embracing the man is now the right arm, giving the visual impression that she is correctly on the man's left, and one would not expect his body to overlap hers. However, in most examples the man's heels or buttocks still overlap the woman's toes or knees. The reason for this may be partly that artists simply made a complete reversal of a group designed originally to face right. In addition, by being made to overlap the woman, the man maintains his dominant position. The resulting groups, which at first sight appear to be a visual muddle, are therefore perfectly logical in Egyptian artistic terms. Nevertheless, by the Eighteenth Dynasty, it had become usual to place the woman's knees over the man's buttocks, so that in right-facing groups the woman appears to be on the man's right, while couples facing left correspond with reality by giving the impression that the woman is on the left.

Originally, figures had been scattered in apparent disorder over decorated surfaces. From the Early Dynastic Period, artists began to divide the drawing surface into horizontal registers placed vertically above one another (fig. 10). The surface was, however, neutral in relation to space and time, and the system of

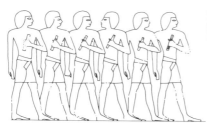

11. Group of scribes in the tomb of Rekhmire at Thebes, Eighteenth Dynasty. (After Davies.)

registers was purely a method of ordering the material placed upon it. It was never developed to indicate spatial relationships between the different registers or pictorial depth by placing objects further away from the viewer in higher registers. Nor did the system give any information about the relationship of the different scenes in time. Although scenes are often loosely linked by theme or location either horizontally within a register or in different registers in sequences up and down the wall, the same basic set of scenes may exist in different versions which arrange individual scenes in varying order, making it plain that their position on the wall and the placing of one scene in relation to another does not itself give information about the order in which to read them. In this they differ from a western cartoon strip which has to be read in a fixed order. The registers on a wall were often given a unity by setting a major figure of the tomb owner or king at one end, overlooking the activities that take place within them (fig. 10).

In any one register, the lower register line was used as the baseline for the figures within it. Sometimes part of a register is divided into sub-registers which provide baselines for smaller

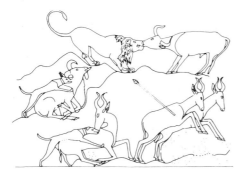

12. Part of a desert scene in the tomb of Senbi at Meir, Twelfth Dynasty. (After Blackman.)

13. Part of a battle scene of king Seti I in the temple of Karnak, Nineteenth Dynasty. (After Wreszinski.)

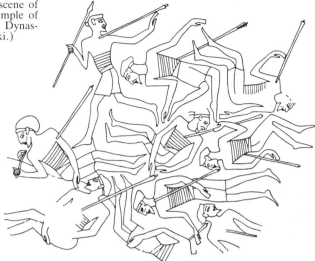

figures within the original register (fig. 10). Even where figures overlap, as in processions of people or herds of animals, giving an impression of depth, the feet of all the figures are firmly placed on the baseline (figs. 10, 11), so that true spatial relationship between the figures, as it would be seen from above ground level, is not represented.

Escape from the use of formal registers developed in desert and battle scenes, where forces associated with chaos rather than the ordered world were depicted. Desert terrain was often represented by undulating baselines (fig. 12), while, in the New Kingdom, set register lines both in desert and battle scenes might be abandoned altogether (fig. 13).

In addition to division into registers, material was organised according to a system of scale, which was used to encode the relative importance of the figures. The larger a figure, the greater its importance, so that in tombs the figure of the owner may overlook scenes in four or five registers and is also often shown larger than members of his family (figs. 7, 10). In royal scenes size helps to distinguish the king from his subjects. This is particularly clear in hunting and battle scenes, where the king's figure dominates the other participants. In temple scenes, which usually depict only the king and deities, there is little variation in scale, since in this context the protagonists are considered to be on an equal footing (figs. 2, 28, 29).

3
Materials and techniques

Egyptian artists worked on a number of materials, of which the foremost was stone, and much of our knowledge of Egyptian painting and relief comes from the decoration of tombs, temples and stelae. Stelae are slabs of stone or, less often, wood that are carved or more rarely painted with one or more scenes and texts. Royal stelae usually commemorate events such as military campaigns or temple building projects; private stelae either relate to the funerary cult of the owner or are dedicated to specific deities and erected in their temples or shrines. Tombs and temples were either rock-cut or built of quarried blocks. The earliest stone used for building was limestone, taken from the cliffs which run along the edge of the Nile valley, into which rock tombs were also cut. Other stones, like granite, sandstone and Egyptian alabaster (calcite), also came to be used. As well as stone, artists worked on materials like wood, ivory and pottery in decorating coffins, furniture and various household items, on papyrus when preparing illuminated Books of the Dead, and on linen when painting cloths used as votive offerings and in funerary contexts.

Before the decoration of temples and tombs could begin, the walls were prepared by polishing to a smooth surface. Any flaws in the stone would be patched over with plaster, while in regions of poor rock the whole area would be covered with a thick layer of plaster to provide a smooth surface for the carving of relief. Where the quality of rock was particularly bad, and also possibly in less expensive tombs, relief was not practicable; instead, the roughly hewn rock was coated with a thick layer of straw and mud and covered with a wash of plaster, on which the decoration was painted.

Once the surface was prepared, whether for relief or painting, the areas which were to contain scenes were marked out with red lines and, from at least the Middle Kingdom onwards, all or some of these were covered with a squared grid used to obtain the correct proportions of figures (chapter 4). The lines were made by dipping a length of string into red paint, stretching it taut across the surface at the appropriate level and then snapping it against the wall; in many unfinished scenes the splashes made by the paint as the string hit the wall can still be seen. As the work was completed, the grid lines were either destroyed when the

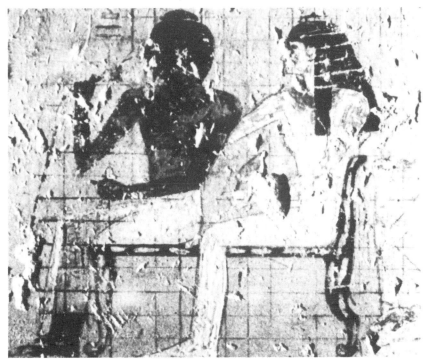

14. Scene showing a scated couple on the original squared grid consisting of fourteen squares from soles to hairline, in the tomb of Tati at Thebes, Eighteenth Dynasty. (Author's photograph.)

surface was cut away and modelled into relief or they were covered over with paint. However, a large number of unfinished scenes from the Middle Kingdom to the Graeco-Roman Period still exist where the grid lines remain visible (figs. 14, 15, 24); further, in some scenes, the background has flaked off to reveal the lines below. The extent to which grids were used in the decoration of monuments varied. In some cases they were placed over all the wall surfaces, while in others they were used only for major figures. In Theban tombs of the Nineteenth Dynasty there is no evidence among the many unfinished scenes that grids were applied at all.

Following the preparation of the wall, the next stage was to draw in preliminary sketches, usually in red (fig. 15). These were often executed by different draughtsmen working on different parts of a composition, but the whole was supervised by the master draughtsman, who would make corrections and draw the

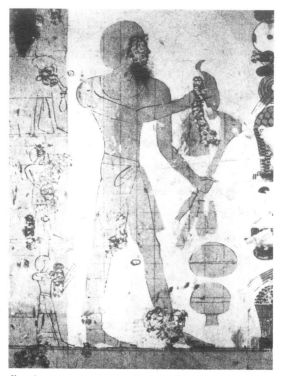

15. Detail of an unfinished scene showing the preliminary sketches of figures and the original grid with the background already painted, in the tomb of Suemnut at Thebes, Eighteenth Dynasty. (Author's photograph.)

final approved version in black. In painted tombs, colour would then be applied, starting with the background (fig. 15), and the whole would be finished by redrawing the outlines of the figures and the details within them with a fine brush (cover). If the scene was to be cut into relief, the outlines of the figures would be incised with a sharp tool. The next step depended on the type of relief used. Two main kinds of relief, raised and sunk, were employed. In raised relief the background is cut away from a scene leaving the figures standing out from the surface of the stone (figs. 2, 7, 16, 19, 28, 31). In sunk relief the surface of the figures is cut away below the background level (figs. 1, 40, 55). In both cases details can then be cut within the figures, which can also be modelled. The sharp shadows engendered by sunk relief make it particularly suitable for use in bright sunlight, which tends to flatten the contours of raised relief. Originally, therefore, raised relief was used inside buildings and sunk relief outside. Since sunk relief involved cutting away only the area of the figures rather than the much larger area of background, it was

used on hard stones, like granite and alabaster, which were less easy to work than limestone. For the same reason, sunk relief was much quicker to execute than raised relief, even on softer stones, so that it came into particular favour in periods when there were large areas to be decorated in a hurry. Probably for this reason, it was used extensively in the great building projects of Akhenaten (chapter 6) and those of Ramesses II in the Nineteenth Dynasty. A further factor, which may have influenced some kings, was that sunk relief made it much more difficult for a successor to usurp their monuments by recutting the stone. The drawback with sunk relief is that the artist cannot obtain the subtlety of modelling and delicacy of line possible with raised relief.

A combination of sunk and raised relief was also developed in which the background was cut away for some distance around figures and objects, gradually sloping back up to the surface level. This avoided having to cut away the whole background, while the surface within the outlines could be treated as raised relief.

The sculptor was not always particularly conscientious in following the lines of the original sketch. Moreover, once the relief was cut, alterations might still be made in the carving by covering the original line with a layer of plaster and cutting a new line. With time, the plaster has often fallen away leaving a confused mass of lines, the deeper showing the first attempt, while the shallower are those which were cut into the plaster and marked the stone below less deeply (fig. 16).

When the cutting was finished satisfactorily, a thin layer of plaster was placed over the surface and the outlines of the figures were redrawn. The background and the figures were then painted in flat masses of colour. Details on the figures together with their final outline were picked out with a fine brush. Just as the sculptor often failed to follow the original sketch exactly, so the painter often did not keep to the relief outlines of the figures.

The artist had a limited range of colours at his disposal, the basic ones being red, yellow, blue, green, black and white. They were derived from mineral pigments, so that they have remained remarkably fresh over time. Red was obtained from red ochre or red iron oxide, found naturally in Egypt. Yellow was made from yellow ochre, which is also a locally occurring oxide of iron, or from orpiment, a natural sulphide of arsenic. Some blue came from azurite, a carbonate of copper present in Sinai and the eastern desert, but the principal blue pigment used was an artificial frit consisting of a compound of silica, copper and calcium. There was in addition an analogous green frit. Green

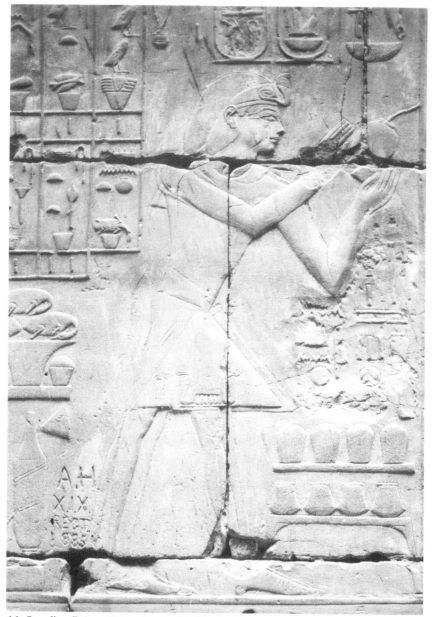

16. Standing figure of king Amenophis III, showing alterations in the cutting of relief, in the temple of Luxor, Eighteenth Dynasty. (Author's photograph.)

was also obtained from malachite, a copper carbonate found in Sinai and the eastern desert; this pigment has not always lasted well. Another natural ore of copper, chrysocolla, was sometimes used, or blue frit and yellow ochre could be mixed to obtain green. Black was generally made from some form of carbon, often soot, but also lampblack, charcoal or plumbago. This last sometimes failed to combine with the paint vehicle and so has now fallen from the wall. White was obtained from gypsum, calcium sulphate, or from whiting, calcium carbonate, both of which occur widely in Egypt.

The ochres would vary in colour from orange through to brown. Orange could also be produced by painting red over yellow or by mixing red and yellow ochres, while brown could be obtained by painting red over black. Black and white mixed together gave grey. From the New Kingdom on, a mixture of gypsum and ochre was used to produce pink.

The pigments were prepared by crushing them on a grinding palette with a stone pestle. Since they were applied on dry plaster, they needed an adhesive as a vehicle, as they would not adhere to the plaster without a binding material; probably a water-soluble gum was used, although both glue and albumen have also been suggested. Egyptian painting is not fresco, as this is painted on to wet or only partly dried plaster; it is rather a kind of tempera.

On the whole, artists worked in flat colours, although in the Nineteenth Dynasty there were experiments in the use of shading. Since the artist had only a limited palette, conventions developed for interpreting natural colours in terms of paint, normally based on the colour of the object represented so that, for example, vegetation is green, water blue and gold yellow. The skin of male figures was reddish brown, while upper class female figures were usually a paler brown or yellow (fig. 14), perhaps indicating that these women spent most of the time in the house, with servants to do the outdoor work. This strong contrast between male and female skin colours may have been an idealisation of reality and it was not always observed. Another convention is applied in processions, whereby the skin colour of the figures alternates between a lighter and a darker shade to make the individuals more readily distinguishable.

Large areas of paint were laid on with coarse brushes made either from bundles of palm fibres doubled over and lashed together at the doubled end to make a handle, or from pieces of wood chewed or beaten at one end to separate the fibres into

bristles. A number of brushes have been found still full of paint
and it seems that separate brushes were kept for individual
colours. The fine outlines of both the preliminary sketch and the
final figure together with the internal details were done with a
narrow reed brush similar to that used by a scribe.

Some painters' palettes have survived, recognisable by the
number of colours present; scribal palettes provided only red and
black. Two miniature palettes belonging to daughters of king
Akhenaten have also come down to us. One has only four
colours, while the other has all six basic pigments of red, yellow,
blue, green, black and white; both have slots to hold reed
brushes. Possibly painting was a childhood pastime for the
princesses.

4
Major figures and formal scenes

Formal scenes are those with a ritual purpose. They depict the
worlds of the gods and the dead; the major figures in them are
those of deities, the king and the tomb owner (figs. 1, 2, 7). They
tend to be static in character and the number of scene types is
limited. In temples the subject matter centres round the ritual
carried out by the king before the god and the reciprocal acts
performed by the god towards the king. In tombs the major
themes show the owner receiving offerings from his family and
estates for his funerary cult, overseeing activities connected with
his estates or office and, from the Eighteenth Dynasty, making
offerings to the gods. These formal scenes were usually drawn on
a squared grid which helped the artists to obtain correct
proportions for the figures.

The figures are shown in an idealised, perfect form. The men
are either youthful and handsome or in prosperous middle age.
The women are eternally young and beautiful, and only accom-
panying inscriptions distinguish between a man's wife and his
mother. Old age, illness and deformity are deliberately excluded.
The poses of these figures are limited to standing, sitting and
kneeling. The impression of violent movement is avoided, even in
scenes showing the king smiting enemies or running before a god
(fig. 17), or the tomb owner spearing fish, fowling (fig. 18) or
hunting; in the best of such scenes a perfectly balanced body is
poised in the midst of action, so that the impression is one of
controlled power. In composition, artists aimed to obtain a
balance between the elements within a scene (fig. 19). In this they
were helped by the prevailing themes in which two or more
figures often confront each other in the acts of offering and
receiving (figs. 2, 28). Also, two scenes of similar type were
frequently placed back to back, making a larger composition in
which the two halves balanced each other (fig. 9). Overall the
character of formal scenes in temples and tombs is static and
unchanging, a world where movement is strictly limited and is
always stately and under control.

Evidence from unfinished scenes shows that Old Kingdom
artists had already developed a system of guidelines to help in the
correct placing of different parts of the body between the soles of
the feet and the hairline. In standing figures a vertical line
marked the central axis of the body, while up to six horizontal

lines indicated the levels of the tops of the knees, the lower border of the buttocks, the elbow, the armpits, the junction of the neck and shoulders and the hairline (fig. 20a). Measurement shows that on carefully drawn examples the level of the kneeline above the soles is one third of the hairline height, the lower border of the buttocks is half the hairline height and the elbow line is two-thirds of the hairline height. The distance from the hairline to the junction of the neck and shoulders is one-ninth of the hairline height.

From at least the Middle Kingdom, these lines were superseded by the use of a squared grid to obtain the proportions of major formal figures; until the Twenty-fifth Dynasty standing figures consisted of eighteen squares from the soles of the feet to the hairline (fig. 20b). Since all the Old Kingdom horizontal guidelines, except for the armpit line, divide the body to the hairline into halves, thirds or ninths, it was possible to fit them on to an eighteen-square grid, so that each guideline corresponded with a grid line. The knee line became grid horizontal six, the lower border of the buttocks horizontal nine, the elbow line horizontal twelve and the junction of the neck and shoulders horizontal sixteen. The vertical guideline which marked the axis of the body was incorporated as a vertical grid line. In the new system horizontal seventeen passed just below the nose, and line fourteen often ran through or near the nipple. The foot was roughly three squares long. The length of the forearm from elbow bone to fingertips measured along the axis of the arm was usually about five squares (figs. 21, 26d). The Egyptian unit of measurement, the small cubit, was probably based on the length

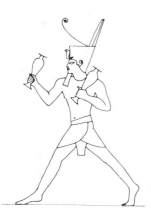

17. Figure of king Amenophis III running before the god Amun-re in the temple of Luxor, Eighteenth Dynasty. (After Brunner.)

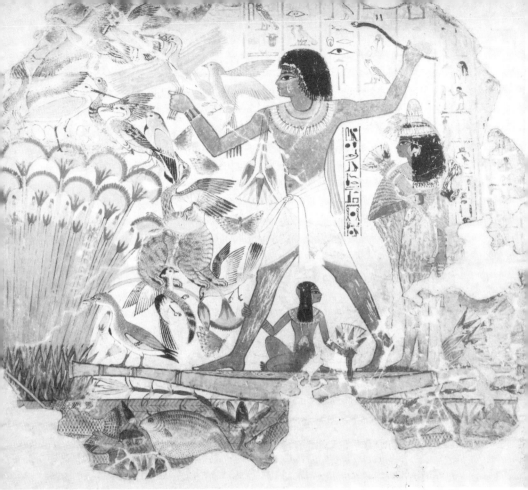

18. Fragment showing the tomb owner and his family fowling in the marshes, from the tomb of Nebamun, Eighteenth Dynasty. (British Museum EA 37977; reproduced by courtesy of the Trustees of the British Museum.)

of the forearm from the elbow bone to the middle fingertip and is roughly equivalent to 450 millimetres (17¾ inches). Therefore, five grid squares should represent 450 millimetres, if the human figure is drawn according to natural proportions. It follows that one grid square equals 90 millimetres (3½ inches). As the top of the head lies eighteen and a half to nineteen squares above the baseline, the height of a standing figure would be the equivalent of 1665 to 1710 millimetres (5 feet 5½ inches to 5 feet 7½ inches). The average living stature of ancient Egyptian males assessed from skeletal remains is about 1700 millimetres (5 feet 7 inches).

Standing figures of women were also drawn on eighteen squares from soles to hairline, but they normally have a higher

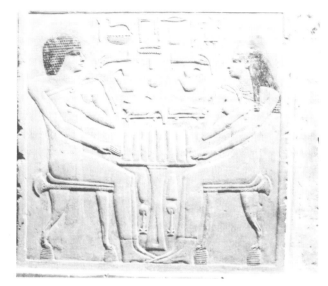

19. Scene showing the seated figures of Iry and his wife, from his tomb at Giza, Fifth Dynasty. (British Museum EA 1171; author's photograph.)

position for the small of the back and are slenderer than their male counterparts (fig. 22). In reality female average height is less than the male, and sometimes this is reflected in the relative heights of men and women in art. Couples may also be rendered with the man and woman the same height or with the woman on a very much smaller scale.

Formal figures in other postures also relate to the grid in a regular way. Seated figures consist of fourteen squares from the

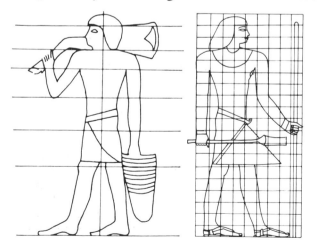

20. *(From left)* **(a)** Standing figure of an offering bearer with guidelines in the tomb of Perneb from Saqqara, Fifth Dynasty. (Metropolitan Museum of Art, New York; after Williams.) **(b)** Standing figure of Sarenput II in his tomb at Aswan, Twelfth Dynasty. Surviving traces of the original grid have been completed to run over the whole figure. (After author's photograph.)

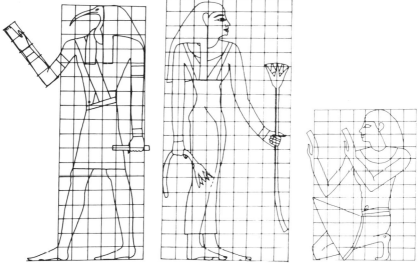

21. (Left) Standing figure of the god Thoth in the temple of Ramesses II at Abydos, Nineteenth Dynasty. Surviving traces of the original grid have been completed to run over the whole figure; in addition five squares have been laid along the axis of the arm to demonstrate its length from fingertips to elbow bone. (After author's photograph.)
22. (Centre) Standing female figure on the original grid in the tomb of Sarenput II at Aswan, Twelfth Dynasty. (After Müller.)
23. (Right) Kneeling figure of Senenmut in his second tomb at Thebes, Eighteenth Dynasty. Surviving traces of the original grid have been completed to run over the whole figure. (After the Metropolitan Museum of Art photograph M8C 183.)

soles to the hairline, since the height of the thigh has been lost (fig. 14). We can, however, see how their proportions relate to those of standing figures. From the hairline to the lower border of the buttocks, on which the figure now sits, is nine squares as in a standing figure. The length of the leg from soles to knee is still six squares, but the top of the knee rises one square above the level of the buttocks, so that only five of the squares of the leg add to the height of the figure, making a total of fourteen squares. The distance from the hairline to just below the nose and from there to the junction of the neck and shoulders is still one square in each case, and the length of the forearm from elbow bone to fingertips is still five squares.

The few grids that survive in relation to kneeling figures show that the distance from the hairline to the lower border of the buttocks is roughly nine squares and the height of the foot from the ball, since the toes are bent under, to the heel, on which the buttocks rest, is about two squares, making a height of eleven squares in all (fig. 23). The proportions of the head between the

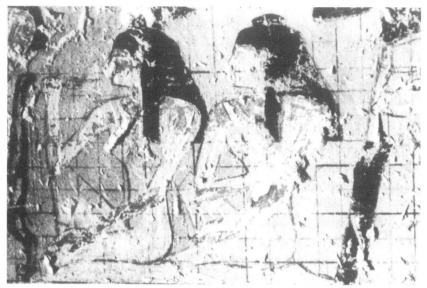

24. Two kneeling figures on their original squared grid, consisting of ten squares from the hairline to the baseline, in the tomb of Tati at Thebes, Eighteenth Dynasty. (Author's photograph.)

hairline and the junction of the neck and shoulders are the same as in standing and seated figures. The length of the lower leg is still about six squares, but it is more variable than in standing and seated figures, since it no longer contributes to the height of the body. No royal kneeling figures are known to survive on grids, but analysis of some figures of kneeling kings shows that their proportions are more suited to a hairline height twelve squares above the baseline. They would still consist of nine squares from the hairline to the lower border of the buttocks, but the foot is longer, being three squares high rather than two.

A variant of the kneeling position occurs when the feet point backwards so that their upper surfaces lie horizontally along the baseline instead of being raised vertically. In such figures, the height from the hairline to the lower border of the buttocks is again nine squares, while the width of the lower leg, on which they sit, is one square, making a total height of ten squares (fig. 24).

From the Twenty-fifth Dynasty onwards grid traces show that standing figures no longer consist of eighteen squares between soles and hairline. Instead, there are twenty-one squares between the soles and the upper eyelid (fig. 25).

Although the grid was originally designed to ensure correct proportions for the human figure, it would be surprising if it did not sometimes influence the artist in the placing of other items in a scene, and there is a tendency for some lines in the composition to relate to the grid. However, relationships between particular objects and the grid were not automatically repeated, and scenes with surviving grids indicate that while grid lines might influence the placing of various objects, there were no rigid rules governing this. A competent artist was capable of drawing accurately freehand, so that the grid was no more than a guide, although it was a useful and even necessary aid for executing large figures above ground level from scaffolding, when it would be impossible to step back to gauge overall proportions.

So far only isolated figures have been considered in relationship to the grid, yet many scenes consist of more than one figure: sometimes they all have the same size and posture; sometimes they are of different sizes. In the first case, one grid will be applicable to all figures. In the second, this will not be so and traces of surviving grids show how artists approached such scenes. Sometimes a single grid appropriate in size to the major figure covers the whole area; other smaller figures in various postures may be added but with no apparent relationship to the

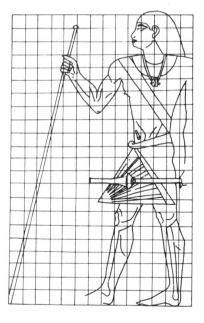

25. Standing figure of Ibi in his tomb at Thebes, Twenty-sixth Dynasty. Surviving traces of the original grid have been completed to run over the whole figure. (After Kuhlmann and Schenkel.)

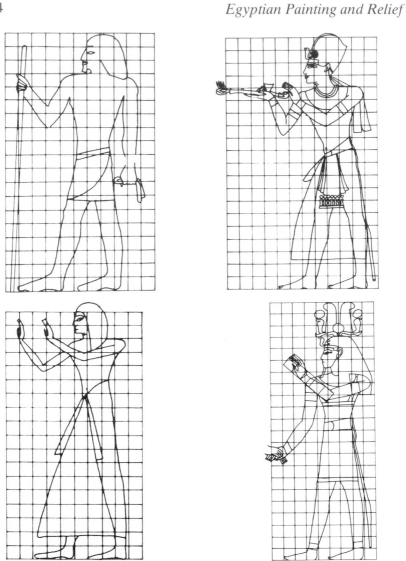

26. *(Top left to bottom right)* **(a)** Standing figure of Herunefer in his tomb at Giza, Old Kingdom, with a hypothetical eighteen-square grid added. (After Simpson.) **(b)** Standing figure of king Seti I in his temple at Abydos, Nineteenth Dynasty, with a hypothetical eighteen-square grid added. (After Calverley.) **(c)** Standing figure of Wenennefer on his stele, Nineteenth Dynasty, with a hypothetical eighteen-square grid added. (British Museum EA 154; after James.) **(d)** Standing figure of the god Ptah-Tatjenen in the tomb of prince Amonhirkhopshef at Thebes, Twentieth Dynasty, with a hypothetical eighteen-square grid added, and five squares placed along the axis of the arm to demonstrate its length from elbow bone to fingertips. (After Kamal el-Mallakh.)

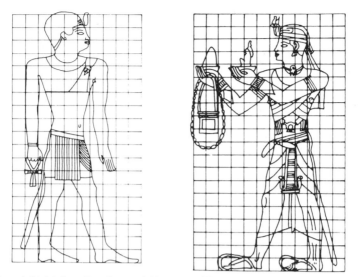

27. *(From left)* **(a)** Standing figure of king Iuput II on a plaque, Twenty-third Dynasty, with a hypothetical eighteen-square grid added. (Brooklyn Museum, New York 59.17; after Fazzini.) **(b)** Standing figure of king Taharqa in temple T at Kawa, Twenty-fifth Dynasty, with a hypothetical eighteen-square grid added. (After Macadam.)

grid lines, except that a horizontal line of the grid often acts as their baseline. In other scenes, separate grids are drawn for figures of different sizes.

Although the principles of rendering the human figure remained the same throughout Pharaonic times, comparison between examples of art from various periods shows that there are stylistic differences. While the traditional eighteen-square grid system provided artists with a guide for establishing bodily proportions, it did not impose a single unchangeable set of proportions for all periods. Minor variations occur between figures on the same monument, but more telling are major variations within the system which noticeably affect the proportions, and therefore the style, of figures. Since different variations tended to become popular at different times, they contributed to the production of the style of a particular period. This can be demonstrated by analysing different standing figures on eighteen-square grids and comparing the results. Where there are no surviving grid traces, a hypothetical grid may be imposed. For purposes of comparison with later figures, Old Kingdom figures may also be analysed on hypothetical grids, although squared grids were not generally used at that time.

In figures of the Old and Middle Kingdoms, the small of the back, the lower border of the buttocks and the tops of the knees usually lie on horizontals eleven, nine and six respectively (figs. 20b, 26a). During the Eighteenth and Nineteenth Dynasties the small of the back and the lower border of the buttocks were often moved upwards by one square (fig.15), while line six, instead of running through the top of the kneecap, may pass through its lower edge (fig. 26b). In some non-royal figures of the Nineteenth and Twentieth Dynasties the small of the back may lie as high as horizontal thirteen, producing a short upper torso and a long lower part of the body (fig. 26c). In some Twentieth Dynasty figures line six runs even lower than the bottom of the kneecap

28. Scene in the temple of Kom Ombo, Ptolemaic Period. (Author's photograph.)

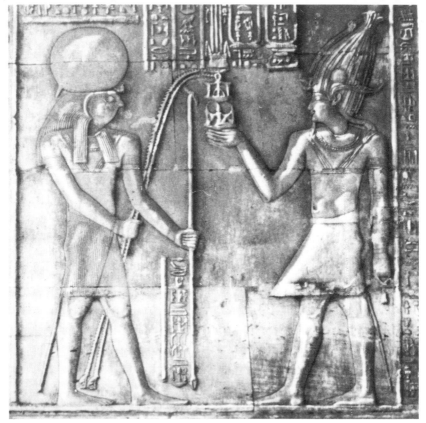

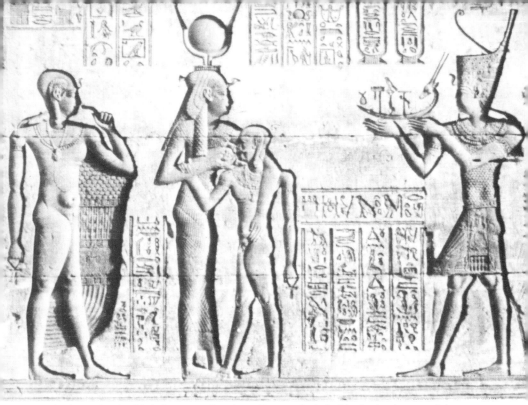

29. Scene in the birth house at Dendera, Roman Period. (Author's photograph.)

through the bottom of the patellar ligament (fig. 26d). By raising the heights of the knee, buttocks and small of the back, artists lengthened the legs in relation to the torso, developing an increasingly elegant rendering of the human figure.

This style came to an end during the late Third Intermediate Period and the Twenty-fifth Dynasty, when a period of archaisation in art based on Old and Middle Kingdom models set in. There was a return to the original low levels of the small of the back, buttocks and tops of the knees (fig. 27a-b). It was about then that the new grid system, which continued to be used until the end of the Graeco-Roman Period, was introduced. During this time, Greek influence caused a new style to evolve, in which figures became much rounder in their modelling, giving them a voluptuous appearance (figs. 28, 29).

5
Minor figures and subsidiary scenes

While the fundamental principles governing the representation of major figures also applied to minor figures, artists had much more freedom in drawing the latter. Whereas major figures had to be depicted as ideal in formal poses, minor figures could be shown as far from perfect, perhaps suffering from deformity, disease or hunger, in postures which caught the body in transitory actions or engaged in energetic movement (fig. 30). While the possible poses for major figures were limited, the range of activities in which minor figures might be engaged was extremely varied. This freedom encouraged experimentation in the representation of human figures in subsidiary scenes. To catch the momentary positions of figures in motion, the body could be shown twisting and turning (fig. 31); occasionally female figures were depicted with their two breasts in full view, instead of just one in profile. There are even examples where figures are shown full-face (fig. 3).

However, the most noticeable difference in the delineation of the body between static major figures and more active minor figures lies in the shoulder region. Instead of the usual full view, the shoulders may be treated in several different ways in order to express different gestures and movements of the arms. One method is where the two shoulders appear to be folded either forward or backward along the central axis of the body (fig. 32 a-b); although not corresponding with reality, the device enabled artists to illustrate a wide variety of activities and postures in a readily understandable way. This method of depiction was occasionally taken over for use on formal figures of kings. A second way was to continue to show the far or forward shoulder in full view, while the near or rear shoulder was drawn in profile, allowing the arm to appear in a whole range of positions (fig.

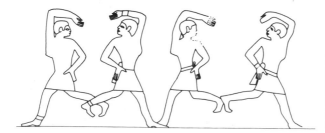

30. A group of dancers in the tomb of Nefer and Kahay at Saqqara, Fifth Dynasty. (After Ahmed Moussa and Altenmüller.)

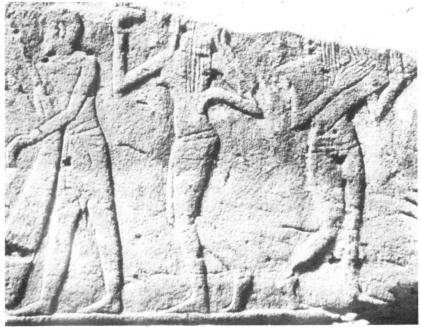

31. Detail of two dancers in shrine 11 at Gebel es-Silsila, Eighteenth Dynasty. (Author's photograph.)

32c). For certain postures a complete profile view of the shoulders was developed (fig. 32d). In the best art it is astonishing how most of these minor figures are successful in terms of expressiveness, even when their postures cannot be translated directly into real terms.

Like major figures, minor ones were still related to the baseline, but figures employed in energetic activities might be depicted with one foot raised or they may leap into the air, leaving the baseline altogether (fig. 33); they do not even always remain vertical (fig. 13). Scenes of fighting, wrestling, running and dancing are infused with movement.

Groups of figures may be ordered in several ways. They may be strung out in a row along the baseline (figs. 11, 34 middle right); the figures are usually shown in similar postures, overlapping horizontally to a greater or lesser extent. While the meaning is unambiguous, such rows may become visually boring and to vary them, and to relate the figures to each other, the head of one of the figures is sometimes turned to look at the figure behind (fig.

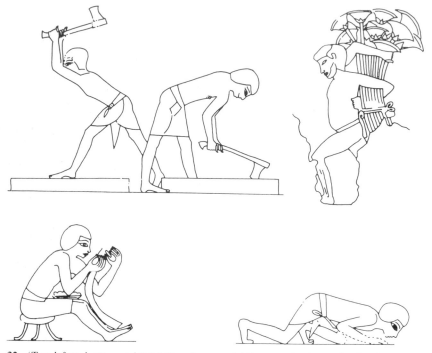

32. *(Top left to bottom right)* **(a)** Two figures wielding axes in the tomb of Rekhmire at Thebes, Eighteenth Dynasty. (After Davies.) **(b)** Figure of a papyrus gatherer in the tomb of Ukhhotpe at Meir, Twelfth Dynasty. (After Blackman.) **(c)** Figure of a man threading beads in the tomb of Rekhmire at Thebes, Eighteenth Dynasty. (After Davies.) **(d)** Figure of a man prostrating himself in the tomb of Rekhmire at Thebes, Eighteenth Dynasty. (After Davies.)

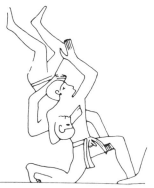

33. Two wrestlers in the tomb of Ukhhotpe at Meir, Twelfth Dynasty. (After Blackman.)

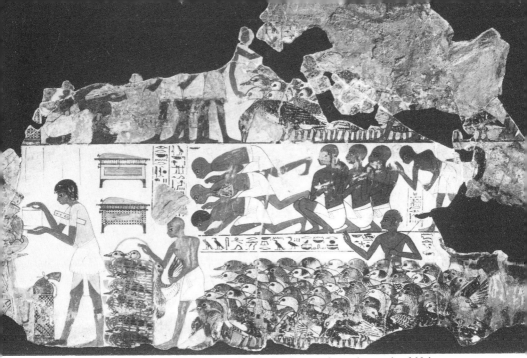

34. Fragment showing the inspection of a flock of geese from the tomb of Nebamun, Eighteenth Dynasty. (British Museum EA 37978; reproduced by courtesy of the Trustees of the British Museum.)

11). A second method is to overlap figures in similar postures in vertical rows, so that the lowest one is on the baseline and each subsequent row placed slightly higher (fig. 34 middle left). A more interesting way was to build up groups from figures in different postures; in good examples the artist achieves a balanced and rhythmical composition growing out of the interplay of limbs and bodies of the various figures (fig. 35).

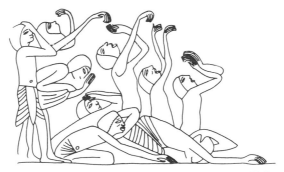

35. A group of mourners from a tomb probably at Saqqara, late Eighteenth Dynasty. (Pushkin Museum of Fine Arts, Moscow I.1.a.6008; after Hodjash and Berlev.)

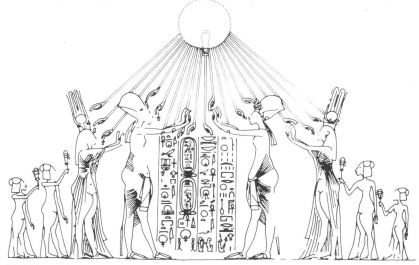

36. (Above) Scene on boundary stele S at Amarna, Eighteenth Dynasty. (After Davies.)

37. (Below) Scene on a private stele probably from Amarna, Eighteenth Dynasty. (Egyptian Museum, West Berlin, 14145; after Aldred.)

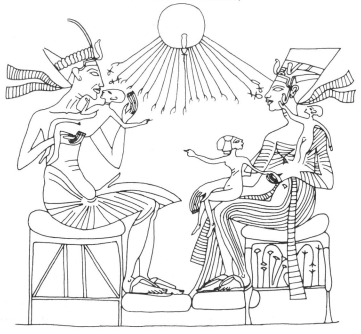

6
Amarna art

At the height of the power of the Eighteenth Dynasty, around 1350 BC, king Amenophis III, who ruled an empire stretching south into present-day Sudan and north into Syria and who presided over the most luxurious court Egypt had ever seen, died and was succeeded by his son, also named Amenophis. Today, the latter is better known by the name Akhenaten, which he adopted in honour of his god Aten. Although Akhenaten ruled for only seventeen years, he managed in that time to introduce a new form of religion which worshipped Aten as the sole god, to build a new capital city dedicated to Aten and to develop a distinctive style of art with which to express his religious ideas and decorate his city.

Aten, which in this context means the 'sun disk', was not a deity invented by Akhenaten, but the king's insistence that Aten was the only god was new to Egyptian religious thinking, which had always been polytheistic. The king not only rejected the traditional gods but also the whole body of cult and myth which had grown up since the dawn of Egyptian civilisation, and which provided themes for temple and tomb decoration. The Aten religion had no mythology of its own, nor any cult images or representation of the god in anthropomorphic form. The living image of Aten was the sun disk, which earlier had been used to symbolise the universal rule of the king of Egypt, who was 'ruler of that which the sun disk encircles'. As a deity, Aten seems to have embodied the concept of divine kingship transferred from earth into heaven; he is the only Egyptian deity endowed with the full attributes of kingship, including the writing of his name in a pair of royal cartouches. The office of king on earth belonged to Aten but he ordained that it should be occupied by his son Akhenaten. Only the king and his family are shown adoring and offering to the Aten directly; lesser mortals adored not the god but the royal family.

Because the great cities of Egypt were too closely associated with the cults of the national gods to be ideal centres for the Aten religion, in the fifth year of his reign Akhenaten founded a new capital called Akhetaten, at the modern site of Tell el-Amarna in Middle Egypt. Within a few years a whole city had sprung up, complete with temples, palaces, private houses and tombs. These were decorated in the newly developed style which is usually

known today as Amarna art after the site of Akhenaten's city. The term is also used to include work executed in this style before the move to Amarna and at sites other than Amarna.

After Akhenaten's death the suppressed cults of the gods were restored, Akhetaten was abandoned and traditional art styles reasserted themselves. Despite the short duration of the Amarna period, this chapter is devoted to exploring various aspects of Amarna art, since at first sight it appears to be so different from traditional Egyptian art.

The distinctive character of Amarna art is due to a number of factors. The erection of new temples at Thebes dedicated to Aten and the setting up of a new city at Amarna entailed a huge building programme. To increase the speed of decoration, extensive use was made of sunk relief, which tends to inhibit the subtle modelling found with raised relief. It seems that, owing to the speed of the building programme, while the best craftsmen were employed on figures of the king and queen, which are usually fairly carefully worked, subsidiary scenes and figures are often less well executed, sometimes degenerating into the inept, although the best can be very lively, creating an impressionistic effect. They also tend to be drawn on a small scale, so that temple and tomb walls seem to be crowded with activities, again possibly a time-saving device.

The god Aten was represented not in an anthropomorphic form like a traditional deity but was symbolised by the sun disk and its rays (figs. 36, 37). As a consequence, many of the time-honoured subjects for temple and tomb scenes were banned while others had to be reinterpreted. Traditional temple decoration consists largely of a series of ritual scenes in which the king adores or offers to the god, is himself embraced by the god and is given the breath of life. In the Amarna period these scenes are all combined into one unvarying scene type where the king adores or offers beneath the sun disk while, at the same time, the Aten rays embrace him and offer the sign of life (fig. 36). While queens and princesses had occasionally appeared earlier in a ritual role in temple scenes, during the Amarna period their presence is almost ubiquitous.

Totally new scene types were developed for the decoration of tombs and private stelae, which almost completely replaced the traditional types showing the tomb owner seated before a table of offerings or standing before a deity. They show the royal family in various domestic situations (fig. 37); since the Aten may not assume an anthropomorphic form, the king and his family seem

38. (Left) Standing figure of king Akhenaten on a limestone slab from the royal tomb at Amarna, Eighteenth Dynasty. Surviving traces of the original grid have been completed to run over the whole figure. (Cairo Museum 10/11/26/4; after Ranke.)

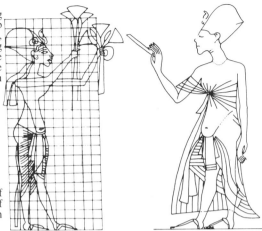

39. (Right) Standing figure of king Akhenaten in the tomb of Mahu at Amarna, Eighteenth Dynasty. (After Davies.)

to substitute as an iconographic focal point.

One of the most obvious ways in which Amarna art departs from the traditional is in the style and proportions of its figures, especially those of Akhenaten and his family. The king is shown with drooping features, a long neck, pot belly, heavy buttocks and thighs, short legs and spindly arms (figs. 36-8). Such gross distortion could have been sanctioned, and probably also devised, only by the king himself. It is a moot point whether it reflects Akhenaten's physical appearance or rather arises in some way as an expression of his religious ideas.

To accommodate the revised proportions of figures, a new grid system was devised. Although there are very few scenes with surviving grid traces, and these all relate to figures of the king, they reveal that artists at Amarna did not abandon the use of a squared grid. They show that standing figures of the king are given twenty squares instead of the traditional eighteen from the soles to the hairline (fig. 38). Using this knowledge, figures without grid traces can be correspondingly analysed on a twenty-square grid. The knee, in most cases the top of the kneecap, lies on horizontal six, the lower border of the buttocks on line nine or ten and the navel on line eleven as in the traditional system. The two extra squares are added above the navel: in many cases, one is inserted between the levels of the navel and the nipple, and one in the neck and face of the figure; sometimes both are placed in the torso region. In traditional figures, the height of the lower leg with the knee on line six is one third of the hairline height, while in the Amarna figure it is less

than a third of the hairline height; three times the knee height often takes one to the level of the throat (fig. 38). The practical effect of this is to make figures look as if they have short legs.

The use of a twenty-square grid was not totally new; remaining grid traces on a wall in the tomb of Tuthmosis IV in the Valley of the Kings show that the figures consist of twenty squares from the soles to the hairline. Their proportions, however, are very different from those of Amarna figures; in some figures the two extra squares are both added in the leg, while in others one is in the thigh and one in the upper torso (cover).

Figures from the early part of the reign of Akhenaten (figs. 36-8) tend to be more extreme in their depiction of the king than later ones. The small of the back is often high, giving a very short upper torso, the waist is narrow and in some cases the head is small, so that one's eye is drawn away from the relatively small upper part of the figure to the large buttocks, wide thighs and prominent belly fold occupying the region midway between the soles and the hairline. In the more moderate figures of the later part of the reign the small of the back is generally lower, giving a more substantial upper torso, and the waist is less narrow, so that the figures as a whole are more balanced in appearance (fig. 39). The relative shortness of the lower leg, however, persists.

Although no grid traces survive for figures of the queen and her daughters, analysis on a twenty-square grid shows that their proportions are quite similar to those of the king, allowing for certain differences between male and female figures. Non-royal figures usually lack the extreme exaggerations exhibited by the king and his family (fig. 40). There are many unfinished scenes in the Amarna tombs which do not involve royal figures, and it is clear that these were not drawn on a grid; their proportions must have been achieved wholly by eye.

Although the proportions of figures were revised and new subjects for scenes were introduced, the underlying principles of representation did not change in the Amarna period. Objects were still represented by their most characteristic view and there was no attempt to show the human figure other than as a composite of its various parts: the head remains in profile with a full-view eye; the limbs are in profile; the shoulders are usually shown from the front, although rendition in profile, drawn from the repertory of minor figures, was sometimes adopted for the king and his courtiers (fig. 36). It became normal for the near foot to be individually represented on figures of the royal family (figs. 37,39), an experiment already made on a few figures in painted

Theban tombs; non-royal Amarna figures were still given undifferentiated feet (fig. 40).

Good artists had always taken care in executing hands, carefully showing the curve of the thumb, tapering the fingers and delineating the nails, so that many depictions of hands are miniature works of beauty (fig. 41a). While the hand was commonly drawn with the fingers together, either clenched or

40. Kneeling figure of Ay in his tomb at Amarna, Eighteenth Dynasty. (Author's photograph.)

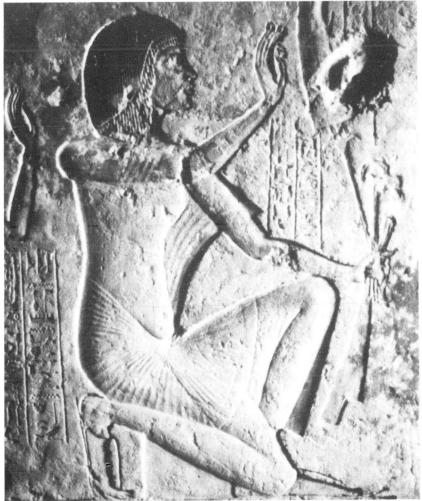

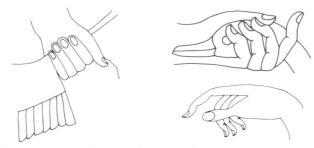

41. (a,b) *(Left and top right)* Details of the hands of a figure on a fragment from a private tomb at Lisht, Twelfth Dynasty. (Brooklyn Museum, New York, 52.130.2; after Fazzini.) **(c)** *(Bottom right)* Detail of a hand on a block from Amarna, Eighteenth Dynasty. (After Cooney.)

open, from quite early on the fingers could also be shown individually engaged in manipulating objects (figs. 3, 41b). An extra refinement loved by many artists was to enhance the elegance of the hand by curving the tips of the fingers slightly backwards. Amarna artists adopted this device enthusiastically, often giving an extreme exaggeration to the curve at the finger tips (fig. 40). They also lengthened the fingers, often making them extremely slender, clearly revelling in the curve of the hand and the details of the individual fingers (fig. 41c).

For all its distinctive style, Amarna art did not depart from the two-dimensional limits imposed by the surface of the area to be decorated, nor develop a way to incorporate a sense of depth. Order was still obtained through the use of registers with figures placed on the baseline, and although running figures may raise the heels of their feet off the ground or lift a foot completely in the air (fig. 42) this is not a new concept to express movement and does not negate the fundamental importance of the baseline. Occasionally a greater cohesion is given to a group of registers by making objects held by figures in one register cross into another (fig. 43). This device is also used in the post-Amarna scenes, executed under Tutankhamun in the temple of Luxor at Thebes, depicting the course of the annual Opet festival when the sacred barks of the deities Amun, Mut and Khonsu were brought by river from Karnak to Luxor. The standards and spears of the companies of soldiers often extend into the lines of hieroglyphs above the register, while ropes attached to the sacred barks cross from one register to another in order to reach the hands of the men who tow them.

The traditional system of registers gave unity to a number of loosely associated activities which might or might not be

contemporaneous or linked by location, and which were ultimately held together by the major figure which dominated the registers, overlooking the activities portrayed. In the Amarna tombs each wall is devoted to one scene which is set in a specific location and often represents activities belonging to a particular occasion. Such large-scale single compositions with a specific background had been used during the reign of Amenophis III, but the stress on location became typical of Amarna art. The setting is usually a definite area within the city, with detailed representation of temples and palaces. Although the scale on which buildings were now shown is new, they were depicted according to principles developed for the representation of architecture in earlier times. Since the artist was no longer dealing with some non-specific idealised world of the dead or the gods but set his scenes in a spatial and temporal framework very much of this world, even major figures of the royal family may be caught in transitory poses.

Groups continued to be shown as rows of overlapping figures, now often bent double in homage to the king (fig. 44a), or as complex groups of figures in different poses united by the interplay between them, so that they form a balanced whole (fig. 44b). The sophistication and expressiveness of the latter contrast strongly with the less imaginative treatment of overlapping figures in rows.

The balance inherent in traditional art remained important at Amarna (fig. 37). The iconography of the sun disk and rays must

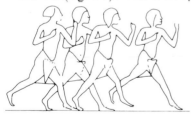

42. (Above) Running figures in the tomb of Mahu at Amarna, Eighteenth Dynasty. (After Davies.)

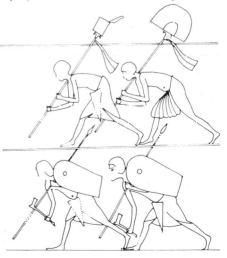

43. (Right) Figures of soldiers in two registers in the tomb of Ahmose at Amarna, Eighteenth Dynasty. (After Davies.)

have been an additional aid to artists composing 'double' scenes since, placed over the central axis of the two scenes, the image would serve to bind both scenes together (fig. 36). In addition, scenes were sometimes constructed so that the descending line of the heads of the royal family, king, queen and princesses, echoed the line of the descending Aten rays (fig. 36).

The traditional use of scale to denote importance remained unchanged, so that scenes are dominated by the large figures of the king and queen, while other figures, including the tomb owner in tomb scenes, are much smaller.

The difference between traditional and Amarna art is one of degree and did not stem from a fundamental difference in the principles of representation employed by the artist. New subject matter was developed to replace the old proscribed scenes and new proportions for the human figure were demanded by the king. Although Amarna art is often regarded as more naturalistic and freer than traditional art forms, it does still adhere to the same basic conventions. The need to find new subjects for scenes and their setting within a particular location and time may, however, have encouraged artists more than usual to incorporate observations from life into their work rather than to repeat traditional learnt forms, thus giving the liveliness and immediacy that are so characteristic of it.

No surviving grids have yet come to light from the reigns of the immediate successors of Akhenaten. However, by analysing figures, one can find out whether the length of the lower leg is a third of the hairline height or less than a third. This method reveals that figures appearing on most items of funerary equipment in the tomb of Tutankhamun have returned to

44. *(From left)* **(a)** Group of scribes in the tomb of Ay at Amarna, Eighteenth Dynasty. **(b)** Group of figures rejoicing in the tomb of Tutu at Amarna, Eighteenth Dynasty. (Both after Davies.)

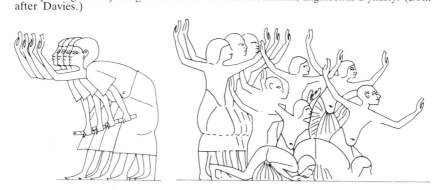

45. *(From left)* **(a)** Tutankhamun on the south wall of his tomb at Thebes, Eighteenth Dynasty, with hypothetical eighteen-square grid. **(b)** Ka of Tutankhamun on the north wall of his tomb, Eighteenth Dynasty, with hypothetical twenty-square grid. (Both after Descroches-Noblecourt.) **(c)** Horemheb in his tomb at Thebes, Eighteenth Dynasty, with hypothetical twenty-square grid. (After Hornung.)

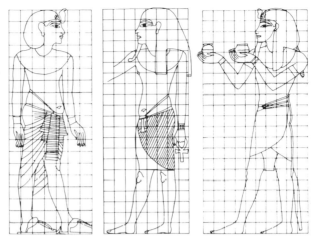

proportions where the lower leg is one third of the hairline height. Analysis of the decoration on the tomb walls shows that on the south wall the length of the king's lower leg to the top of the knee is unequivocally a third of the hairline height (fig. 45a), while on the north wall the lower leg of the king and his double or *Ka* is only a third of the height to the chin and not to the hairline (fig. 45b). It is clear that the artists working on the north wall were still thinking in terms of proportions appropriate to a twenty-square grid, while those engaged on the south wall had embraced the reintroduced eighteen-square system. The hairlines of the figures on the north wall lie at different levels, which is unusual in a row of figures and suggests that there may have been no overall grid placed on the wall; possibly grids were not used at all, the figures being drawn freehand.

Since the decoration of Tutankhamun's tomb took place after his death, while his funerary equipment, using figures with traditional proportions, was prepared before he died, it is extraordinary to find figures on the tomb walls still with the short lower leg associated with Amarna figures. Yet not only is the short lower leg found in this tomb, but it also occurs in the next three royal tombs of Ay, Horemheb (fig. 45c) and Ramesses I. At first sight the Amarna influence is not obvious, since the drooping features, enlarged buttocks and heavy thighs have been abandoned and the subject matter of the scenes is once more orthodox, but it is not until the decoration of the tomb of Seti I that traditional proportions were again applied in the royal necropolis.

46. *(From top left)* **(a)** Fragment showing birds flying over a papyrus clump, from a painted palace floor at Amarna, Eighteenth Dynasty. (After von Bissing.) **(b)** Detail showing bouquets and a stand with a bowl of food, from a painted palace floor at Amarna, Eighteenth Dynasty. (After Pendlebury.) **(c)** Detail from a painted palace wall at Amarna, Eighteenth Dynasty. (After Frankfort.)

7
Art in domestic and informal contexts

So far most of the art considered comes from temples and tombs, since such monuments provide by far the largest and best preserved source of material. By contrast, our information on domestic decoration is limited, partly because there has been comparatively little excavation of settlement sites and partly because of bad preservation. Work has been carried out at the palace of Amenophis III at Malkata in Thebes, Akhenaten's city at Amarna and the workmen's villages at Amarna and Deir el-Medina at Thebes, giving us some idea of their decoration. The habit of putting everyday items into tombs has preserved much domestic art that would otherwise have been lost.

Unlike temples and tombs, which were built of stone or cut from rock to last for all eternity, domestic dwellings, even royal palaces, were built of mud brick and had a limited length of life. The brick walls were covered with a layer of white plaster and were then often decorated with painted scenes. The themes of these were not drawn from the worlds of the gods and the dead found in temples and tombs. One common subject for depiction was the household god Bes. This dwarflike creature, usually with the features, ears, mane and tail of a lion, had no national cult in the temples but was the protector of women in childbirth and of the household in general. His figure is found decorating the walls of the lowly houses of the workmen's villages at Amarna and Deir el-Medina and of the luxurious palace of Amenophis III at Malkata; it is also a popular motif in the decoration of furniture.

Within palaces decoration was partly designed to reflect and enhance the regality of the king, so that scenes of the king enthroned might flank the actual throne of the king or a floor might depict the bound enemies of Egypt on which the king had to tread every time he crossed it. Many elements of domestic decoration were, however, drawn from the natural world, and superb fragments of painted plaster survive from the floors, walls and ceilings of the palaces of Malqata and Amarna. The floors were often decorated with a large composition having as its centre a rectangular pool, usually containing plants and fish, surrounded by one or more borders with clumps of plants including papyrus, and birds flying above them (fig. 46a). Calves might leap among these plants, and formal bouquets and stands supporting bowls of food could also appear (fig. 46b); human beings, however, had no

47.(Left) Detail showing pigeons and butterflies from a painted ceiling in the palace of king Amenophis III at Malkata, Thebes, Eighteenth Dynasty. (After Tytus.)
48.(Right) Detail of the handle of a cosmetic spoon, showing a naked girl in a papyrus thicket, from Sedment, Eighteenth Dynasty. (New Carlsberg Gallery, Copenhagen, AE.I.N.1559; after Mogensen.)

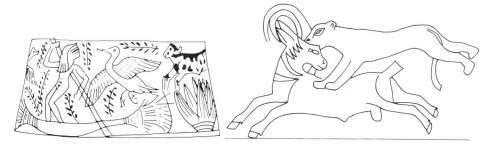

49. (Left) Detail of the decoration on a blue-painted pottery jar, showing a girl punting in the marshes, a bird and a leaping calf, late Eighteenth Dynasty. (Brooklyn Museum, New York, 59.2; after Fazzini.)
50. (Right) Detail from a carved ivory box from the tomb of king Tutankhamun, showing a cheetah attacking an ibex, late Eighteenth Dynasty. (After Edwards.)

place there. The naturalism of the individual motifs contrasts with the highly formalised floor plan. Similar motifs also occur on walls in various combinations (fig. 46c). Two different styles of execution were used: in some of the work the drawing is extremely careful, producing the texture of leaves and petals and

51. Details of pigeons caught in a clap net, in the tomb of Neferherptah at Saqqara, Fifth Dynasty. (After Peck and Ross.)

the plumage of birds by minute attention to detail; elsewhere the style is sketchy and impressionistic. Ceilings, since they might be thought of as representing the sky, were sometimes decorated with birds (fig. 47); plants and water were not appropriate. Also favoured were coloured geometrical patterns; these often incorporated interlocking spirals, which have links with Aegean designs.

Many of the naturalistic themes found on floors and walls also occur on everyday household items like furniture, cosmetic objects, faience bowls and pottery (fig. 49). In addition, the motif

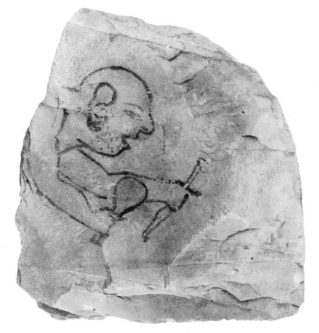

52. Ostrakon showing a sketch of a stonemason; Ramesside. (Fitzwilliam Museum, Cambridge, EGA 4324.1943; reproduced by courtesy of the Fitzwilliam Museum.)

53. Ostrakon showing a sketch of a baboon from Amarna, Eighteenth Dynasty. (Petrie Museum of Egyptian Archaeology, UC 1585; reproduced by courtesy of the Petrie Museum, University College London.)

of a naked or almost naked young girl is very common; sometimes she plays a musical instrument or carries bunches of flowers, and she is often set against a background of marsh plants (figs. 48,49). Another popular theme, already appearing on a steatite disk of the First Dynasty, shows a predator, such as a lion, panther or hound, attacking and pulling down its prey (fig. 50). Although in general domestic art derives from natural forms, many of its elements also have a particular symbolism; for instance, the lotus signifies rebirth and the fish fertility.

Many of the features of domestic art have parallels in subsidiary tomb scenes, which include, for instance, calves prancing, birds trapped (fig. 51) or flying free (fig. 18), clumps of marsh plants (fig. 18), animal combats (fig. 12) and, in the Eighteenth Dynasty Theban tombs, scantily clad girls as servants or dancers (fig. 3). Although the overall compositions found in tombs are very different in character from those used in domestic decoration, there are clearly similarities linking some of the individual elements.

Thousands of fragments of pottery and flakes of limestone, called ostraka, which formed a supply of readily available drawing material, have survived. On them, artists and their apprentices, using a fine reed brush and red or black paint, might copy or design scenes, practise drawing particular items from the artistic repertory or simply sketch and doodle for their own amusement. Many of these drawings may have been initial sketches of elements that were to be worked up for temple or tomb scenes; others have subjects which could not be part of such scenes (fig. 52) and may show the artist drawing for his own pleasure. Some of the most successful sketches possess a deft fluidity and economy of line (fig. 53).

8
Conclusion

The previous chapters have shown how the Egyptian artist set out to create his composition according to principles that are completely different from those underlying western art. He treated his drawing surface as a two-dimensional area without depth, on which he organised his material by means of horizontal registers which have no reference to time or space, using scale to encode importance. Objects, including the parts of the human body, were symbolised by their most striking aspect. In religious art the purpose was to create the formal, unchanging and idealised worlds of the gods and the dead, which are consequently static in character. When tackling more mundane subjects, artists could produce scenes full of motion and vitality. The rendering of the human figure was not taken straight from life, but various devices were used to build up the individual parts of the body into a composite scheme. Although the resulting figures do not equate directly with reality, it is remarkable that they 'work', that is to say, in spite of distortions they are expressive as well as being readily understood. The stylisation does not exclude a sense of movement where that is appropriate; its absence in formal temple and tomb scenes is due to the context not to any lack of skill.

As everywhere, not all artists were of the same standard. There were periods of general artistic decadence as, for instance, during the First and Second Intermediate Periods. At other times the best artists were usually employed on royal projects or by high officials. Less wealthy and provincial patrons often had to be content with second-rate or even bad products. In these, the sense of fine order is often lost, so that composition tends to be unbalanced, with internal elements haphazardly placed; register lines may even be abandoned. Individual figures often exhibit incorrect proportions (fig. 54), inept draughtsmanship and poor cutting of relief (fig. 55). A comparison between two treatments of a similar subject will illustrate some of these points. The two scenes in figures 56a and b are both taken from private stelae of the Middle Kingdom. Each shows a man and a woman seated side by side, depicted according to Egyptian artistic convention by placing one figure in front of the other (chapter 2). In figure 56a the two figures overlap and the woman's forward arm is placed round the man's shoulders. In front of the seated figures a selection of offerings is built up into a neat group. The whole

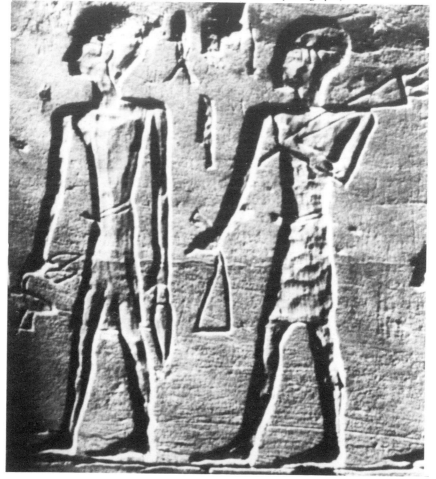

54. (Left) Detail of the figure of a seated man on a stele from Abydos, Middle Kingdom. (Louvre Museum, Paris, C16; after Simpson.)

55. (Below) Two figures in the tomb of Heqaib at Aswan, Sixth Dynasty. (Author's photograph.)

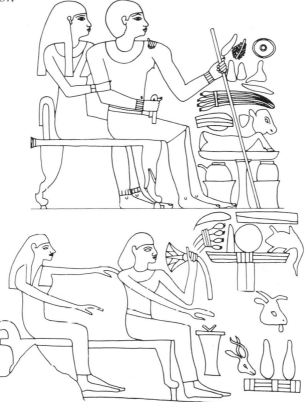

56. *(from top)* **(a.)** Scene showing a seated couple on a private stele, Twelfth Dynasty. (Kestner Museum, Hanover, 2927; after Brunner.) **(b)** Detail of a seated couple on a stele from Abydos, Middle Kingdom. (National Museum, Copenhagen, Aad 13; after Simpson.)

composition is compact and balanced. By contrast, in figure 56b the two figures are seated so far apart that the woman only just touches the man's rear shoulder with her fingertips; the space between them is left empty. The offerings in front of the figures do not form a connected group. The drawing of the woman's figure is especially inept in the region of the rear upper arm, while the feet of both figures fail to reach the baseline. The composition sprawls over the surface, lacking the balance inherent in good Egyptian art.

The reader may like to consider, during visits to Egypt or to Egyptian collections in museums, to what extent a particular piece meets the aims and achievements of the best artists or where it falls short of them.

9
Museums to visit

Intending visitors are advised to find out the opening times before making a special journey.

Ashmolean Museum of Art and Archaeology, Beaumont Street, Oxford OX1 2PH. Telephone: 0865 278000.

Bolton Museum and Art Gallery, Le Mans Crescent, Bolton, Lancashire BL1 1SA. Telephone: 0204 22311 extension 2191.

British Museum, Great Russell Street, London WC1B 3DG. Telephone: 071-636 1555.

City of Bristol Museum and Art Gallery, Queens Road, Bristol, Avon BA1 1RL. Telephone: 0272 299771.

Durham University Oriental Museum, Elvet Hill, Durham DH1 3TH. Telephone: 091-374 2911.

Fitzwilliam Museum, Trumpington Street, Cambridge CB2 1RB. Telephone: 0223 332900.

Liverpool Museum, William Brown Street, Liverpool, Merseyside L3 8EN. Telephone: 051-207 0001 or 5451.

Manchester Museum, The University of Manchester, Oxford Road, Manchester M13 9PL. Telephone: 061-275 2634.

Petrie Museum of Egyptian Archaeology, University College London, Gower Street, London WC1E 6BT. Telephone: 071-387 7050, extension 2884.

Royal Museum of Scotland, Chambers Street, Edinburgh EH1 1JF. Telephone: 031-225 7534.

57. (Opposite) Map of ancient Egypt, showing places mentioned in the text.

10
Further reading

Aldred, C. *Old Kingdom Art in Ancient Egypt*. Tiranti, 1949.

Aldred, C. *Middle Kingdom Art in Ancient Egypt 2300-1590 BC*. Tiranti, 1950.

Aldred, C. *New Kingdom Art in Ancient Egypt during the Eighteenth Dynasty 1570-1320 BC*. Tiranti, second edition 1961.

Aldred, C. *Akhenaten and Nefertiti*. Thames and Hudson, 1973.

Aldred, C. *Egyptian Art*. Thames and Hudson, 1980.

Brunner-Traut, E. *Egyptian Artists' Sketches. Figured Ostraka from the Gayer-Anderson Collection in the Fitzwilliam Museum, Cambridge*. Nederlands Historisch-Archaeologisch Instituut te Istanbul, 1979.

Cooney, J. D. *Amarna Reliefs from Hermopolis in American Collections*. Brooklyn Museum, 1965.

Harris, J. R. *Egyptian Art*. Spring Books, 1966.

Lucas, A. *Ancient Egyptian Materials and Industries* (edited by J. R. Harris). (edited by J. R. Harris). E. Arnold, fourth edition 1962.

Mekhitarian, A. *Egyptian Painting* (translated by S. Gilbert). Macmillan, 1978.

Page, A. *Ancient Egyptian Figured Ostraca in the Petrie Collection*. Aris and Phillips, 1983.

Peck, W. H. *Drawings from Ancient Egypt*. Thames and Hudson, 1978.

Schäfer, H. *Principles of Egyptian Art* (translated by J. Baines). Oxford University Press, 1974.

Smith, W. S. *A History of Egyptian Sculpture and Painting in the Old Kingdom*. Oxford University Press, second edition 1949.

Smith, W. S. *The Art and Architecture of Ancient Egypt*. Penguin Books, second edition (revised by W. K. Simpson), 1981.

Wilkinson, C. K., and Hill, M. *Egyptian Wall Paintings: The Metropolitan Museum of Art's Collection of Facsimiles*. Metropolitan Museum of Art, New York, 1983.

Acknowledgements

I would like to thank the Egyptian Antiquities Organisation both for their permission to take photographs inside tombs and for all the help I received in the course of my work at Luxor and in Middle Egypt during the spring of 1984. I am also extremely grateful to the Wainwright Near Eastern Archaeological Fund for a grant enabling me to pursue my research in Egypt. Thanks are also due to the Trustees of the British Museum, to the Petrie Museum, London, and to the Fitzwilliam Museum, Cambridge, for permission to reproduce photographs, to Miss Miriam Stead for showing me examples of painters' equipment in the British Museum, and to Mr Peter Starling for his invaluable help with photography; drawings are by the author. Finally, I would like to express my gratitude both to my husband for his encouragement and unfailing patience and to my parents for all their help over the years. Acknowledgement is made to W. J. Murnane and Penguin Books Ltd for permission to reproduce in abbreviated form the Chronology on page 5.

Index

Page numbers in italics refer to illustrations.